The London International
Festival of Theatre Lecture

the search *for* meaning

Also by Charles Handy

Understanding Organisations
Understanding Schools as Organisations
Understanding Voluntary Organisations
Inside Organisations
The Age of Unreason
Waiting for the Mountain to Move
Gods of Management
The Empty Raincoat
Beyond Certainty

the search *for* meaning

Charles Handy

In association with the
London International Festival of Theatre

First published in Great Britain 1996
by Lemos & Crane
20 Pond Square, Highgate
London N6 6BA

in association with
London International Festival of Theatre
19–20 Great Sutton Street
London EC1V 0DN

ISBN 1-898001-22-7
A CIP catalogue record for this book is
available from the British Library
Design by Richard Newport
Printed and bound by Butler & Tanner,
Frome and London

CONTENTS

The Aids To Meaning

Questions and Answers

In Memory of Barney Simon

Acknowledgements

Index

Foreword
HELENA KENNEDY, QC

'The poet's eye, in a fine frenzy rolling,
Doth glance from heaven to earth, from earth to
heaven;
And, as imagination bodies forth
The forms of things unknown, the poet's pen
Turns them to shapes, and gives to airy nothing
A local habitation and a name.'
(Theseus from *A Midsummer Night's Dream*)

I am honoured to introduce *The Search for Meaning*. The opportunity for this publication arose from the summer events of the eighth London International Festival of Theatre (LIFT).

LIFT has been celebrating the best in international contemporary theatre and performance since 1981. In gathering together over five hundred of the world's most innovative and adventurous theatre artists, LIFT presents London – a great `world city' if ever there was one – with a potent meeting place of philosophies and cul-

tures. With such a bubbling crucible of today's ideas at its heart, the Festival sheds light on what it is to be human today. As a result perhaps, LIFT is well placed to pose some of the most urgent and elusive questions of our secular times: do our lives have meaning? How do we find meaning and how do we choose to express it?

Love, beauty, loneliness, responsibility, and death are among the things, suggests Charles Handy, that we must come to terms with if we are to find a sense of meaning in our busy, urban, work-orientated lives. Almost uniquely of the professions, artists immerse themselves daily in reflections on such matters. They celebrate the imponderables and mysteries we dwell upon, but cannot always name: hopes, fears, joy, despair, emotions strongly felt, ideas only half apprehended. In the realms of the artist's imagination, we find our lives reflected, our perspectives changed, and our spirits uplifted.

New freedoms have brought new confusions

for us. In what can only be described as revolutionary times, it is inspiring to find those who can speak with clarity. Charles Handy and Barney Simon have been two such people, throwing out beams of light that help us all to see more clearly. LIFT '95 invited them both to use its world platform to express their views in times of intense change in society, in Britain and South Africa respectively: an invitation to consider the ways in which art can serve to reflect and influence the times we are living in.

Tragic circumstances prevented the first lecture taking place. A courageous and outspoken opponent of apartheid and an inspirational theatre director, Barney Simon, died on 30 June 1995. Artistic Director and Co-Founder of The Market Theatre, Johannesburg, Barney Simon made an enormous contribution to the development of theatre in South Africa and beyond. His death at such a critical time in the new democracy is a cause of great sorrow. However his profound belief in the power of the theatre to affect people's lives forever lives on in the the-

atre he created. The lucidity of his vision can be seen in the short address published for the first time in this book.

Happy circumstances ensured that Charles Handy spoke to a packed audience at the Institute of Contemporary Arts in London. The publication of his lecture ensures that his passionate interest in the arts and his interpretation of how they can aid a search for meaning in life is more widely shared.

Charles Handy and Barney Simon both recognise the theatre as a place for reflection: a space in which we can see, listen, think and learn. Combining sagacity and common sense, both men embrace a view of our spirituality and humanity with simple directness.

In different ways, both demonstrate a belief in people's capacities to change, if only in their desire to fulfil their life's potential. In this aspiration there is hope and in the hope some meaning. I have found this publication a cause for inspiration. I hope you do too.

Finally, we extend our thanks to Charles Handy for his generous support in allowing us to publish his lecture in aid of the Festival.

Helena Kennedy, QC
Chair of the Board of Directors of LIFT

INTROD

JCTION

Introduction

For me, the theatre is a window on the world, as are all the arts. One does not have to be an expert in the theatre or any of the arts in order to get meaning from them. All you have to do is to sit, look, listen and, above all, think.

For me it is the arts, and theatre in particular, which deal best with the great indefinables of life: truth, beauty, love, joy, loneliness, death, responsibility, madness, meaning. We do not really know how to define any of those things, yet they are at the core of everybody's life. If we want to get any sense of them, in these troubled times, then the arts are our best hope.

Let me give you an example: One of the theatre events staged during the London International Festival of Theatre during the summer of 1995 was The Volksbühne Theatre from Berlin performing *Murx Den Europäer! – Ein Patriotischer Abend* (*Murx the European! Murx Him! A Patriotic Evening*) by Christoph Marthaler. This

was a wonderful, theatrical experience, although I would hesitate to call it a play. It took place on a huge stage in a warehouse at Three Mills Island in Stratford East, London. Eleven people sat still and silent at separate tables. They appeared to be unaware of each other's existence. The clock had stopped. It had stopped at the moment when the German Democratic Republic of East Germany ended and Germany was unified, which effectively meant that the West Germans took over. They sit there, these people, having been told, in effect, that the last forty years of their lives were of no avail. They are sitting there waiting for nothing. All they can hold onto are their memories, their fantasies, their personal idiosyncrasies, their little daily routine.

Murx was not an evening in the theatre to enjoy, but I came away thoughtful. It is too easy to say, 'Well, that's Berlin, that's what happened to the East Germans.' But there are an awful lot of people around in our society today who are sitting waiting for nothing. They have

nothing to fall back on except their nostalgic memories, their own personal feelings, their little tiny daily routines.

We need to be reminded of such people, because most of the time we do not see them. We can always choose, in life, what we choose to see, can't we? But people have to think about these things. It is not easy. Here is an extract from a poem by David Whyte:

'It is difficult
to get the news from poems.
Yet men die miserably every day
for lack
of what is found there.'

What is true of poems, is true also of the theatre, and all the arts. We have to work at them to get the news. If people deprive themselves of these opportunities, there is no chance to find out what life is really all about. And life, our life, is changing beyond all recognition. All certainty has gone, leaving behind unanswered questions and a new freedom.

charles handy

one
SEAR
FOR
MEAN

HING

NG

God, or Gertrude Stein

We are moving into a new world. I grew up in a world where some things seemed certain. I grew up in a world where I was told, not that I totally believed it, that there was a God, who had started things and who was there to see that things somehow worked themselves out. I do not think that most of us now believe in any Supreme Being sitting up there guiding our ways, though some might do, and others perhaps hanker after it. But, if not God's creation, what is life?

When Chekhov was asked, 'What is life?', he said, 'It is like asking what a carrot is. A carrot is a carrot.' Gertrude Stein said of Oakland, California, 'The trouble with Oakland, California, is that there's no there, there.' She is right about Oakland. She might be right about life too. Perhaps there is no there, there. Somehow we are not sure what it is all about any more.

This uncertainty is nothing new. It started way back in the Renaissance in Italy. In those days there was a sort of certainty. The Popes and the priests knew the answer, or said they did. Then the printing press was invented. People no longer had to believe the Popes and their priests. People could read the Bible in their own language in the privacy of their own homes. They could make up their own minds. This was a great new freedom. The result was, inevitably, that the church lost its authority, while there was a lot of new creativity and bubble around. The Renaissance was an exciting time but there was also a lot of violence, as people tried to say, 'Well, this is the way I think it should be.' There were wars and feuds and oppression, as well as the creativity.

I believe that we are seeing something similar today. Television, radio and the Internet encompass the world. Presidents, kings and queens, prime ministers, princes, all have lost some of their authority. Everyone can know as much as they do. We can all make up our own minds

about everything, and we do. It is confusing, creative and destructive all at once. We have to unlearn the things and the ways we once knew.

From Shell to portfolios

The trouble is that the more I see of the world, the more I seem to be only a pimple. What difference can I make? Let me just be busy with my own little life. But, even there, there is no certainty.

When I left university many, many years ago I joined the great corporation Shell. The first thing they presented me with was my pension book. I was twenty-one years old. By way of reassurance, they said that the pension fund was extremely rich and would be richer still for my widow, should I eventually marry, because, they said people did not usually live for more than eighteen months after they retired from Shell. Shell had my life mapped out. They put a

piece of paper in front of me on which I was glad to see a line going gradually upwards, marking out a typical career with Shell, until I would retire, and then die (eighteen months later!). However, this was not what transpired. Both the little company where I was to be the general manager and the country itself did not exist when the time eventually came. By then the world had completely changed. But by then I was not with Shell.

What amazes me, casting my mind back to that time, was that I was terribly glad to have my entire life settled in advance. Shell would tell me where to go, what to learn and what to do. Furthermore, I had actually handed over to Shell the definition of my priorities in life. Success was clearly going to be doing well at Shell, whatever that might be. Happiness was to be a happy Shell executive. I was not aware of having pledged myself to that, but that is what I had done in fact, and I was happy about it. There was a sense of certainty. Yet when I look back I am amazed that I was prepared to hand

over my life and my purpose to some anony-
mous corporation.

There are, probably, many people who still
want to have this kind of life, and this certainty,
but it is not possible any more. It is becoming
clear that the world of organisations is splitting
up. The move is from a company like Shell to
what I call portfolios. This means that more and
more people have to assemble for themselves a
collection of clients, a jigsaw of work. There are
no longer any 'jobs for life'. How could there
ever have been?

The average life for big business corporations
has always been less than forty years. One
wonders how these organisations ever had the
impudence to offer fifty year careers to people.
It did happen, nonetheless, but now no longer.
These days people stay with corporations for
five years, ten years or perhaps fifteen years.
After a sequence of projects you are back on
your own, one way or another.

Statistics show that, by the end of this decade, 50 per cent of the workforce will be effectively outside organisations. Thirty per cent will be temporary staff or part-timers. Twelve per cent, maybe even 15 per cent, will be officially self-employed. There will still be seven or eight per cent totally unemployed, I hope not more. Over 50 per cent of the workforce will then not have permanent jobs, or full-time jobs, inside a corporation.

The world will have totally changed. It is already changing. We are on our own. If you are not on your own now, believe me, you will be by the time you are forty-eight or fifty. Capitalism, in fact, has destroyed certainty, which is not what it was meant to do.

Capitalism but... Francis Fukuyama

You may not be aware that 14.4 per cent of all households in Britain have nobody in them earning any money at all. It has always been the

assumption that there would be at least one earner inside every household, possibly just a few households without anybody. Now it is said that you have to have a least two earners to have a decent life. Yet there are 14.4 per cent households with no earners at all.

Capitalism was meant to be another kind of certainty while communism, not capitalism, was going to self-destruct. Capitalism was going to make us all rich. It has made some people rich, that is certain, but others not so rich.

We recently met a young executive in Dresden, in eastern Germany (the old GDR). He was comparing life under the former communist system with life under the new capitalist system. He said, 'The old system didn't work, of course. It was ruining the economy, ruining the physical environment and ruining our lives, in a sense. But,' he said, 'at least, under that system, we were all paid the same, whether you worked hard or not so hard, productively or not so productively. At least under that system there was

an awful lot of time left for families and friends, for festivals and fun, all the four Fs.'

Now it's all productivity, pay, performance and profit, the four Ps,' he said. 'Just sometimes I wish,' he said, 'in the midst of the four Ps, which are making me richer, there was some time left for the four Fs, which made me human.'

We have now got a society, where some are getting all the Ps with no time for the Fs and some have all the Fs, but no Ps to pay for the Fs! That is a strange kind of world. Capitalism does not seem to be working quite as well as we all thought it would.

Francis Fukuyama wrote a book called *The End of History*. It sounded like an optimistic book, preaching a 'we've-got-it-all-sorted-out' message. A mixture of capitalism and democracy, and the world is solved. However, what Fukuyama says in the end is this:

'The end of history will be a very sad time. The

struggle for recognition, the willingness to risk one's life for a purely abstract goal, the world-wide ideological struggle that called for daring, courage, imagination and idealism will be replaced by economic calculation, technological problems, environmental concerns and the satisfaction of sophisticated consumer demands. In the post-historical period there will be neither art or philosophy. Just the perpetual care-taking of the museum of human history.'

I have an awful feeling that Fukuyama is proving to be right. He said that, in future, we shall compete only for gold medals at the Olympic games, not for anything more grand. We shall, he said, under this mixture of democracy, capitalism and materialism, elect our politicians and we will then lie down on our backs like dogs in the sun and ask them for more. If the politicians fail to give us more, then we will elect other people. That is what our striving will be about. Is that what capitalism and democracy was meant to bring? Is that the meaning of life? I do not think so.

Richard Dawkins, or …
Heisenberg?

There was, however, another form of certainty. This came from science. Exemplified most recently, perhaps, by Richard Dawkins, who writes seductive and wonderful books: *The Selfish Gene*, *The Blind Watchmaker*, and his lastest, *River Out of Eden*, which essentially brings Darwin up to date. He says that everything that is in ourselves and our surroundings has evolved in this competitive natural world, and that all we have to do is to strive to reproduce, because only the best of us will be able to reproduce in the end. He concludes that there is nothing much we can do about anything, because it is all fixed in our genes.

That is one form of certainty. Stephen Hawking goes further. 'We shall,' he said, 'in due course, know the mind of God.' All is fixed therefore. All we can do is to lie back and enjoy it and have another beer. There is no point in reading books … Or going to the theatre … It is all set – or is it?

We cannot ignore Heisenberg of the uncertainty principle; Heisenberg who, on his deathbed, said to a friend, 'When I meet the Creator, I shall ask Him two questions: why relativity and why turbulence? And' he said, 'I think He may have an answer to the first, but not to the second.' Who can explain this inevitable turbulence, and what can we do about it? It cannot be managed.

If you want a notion of what turbulence is like, think back to a performance in the theatre which you didn't understand or enjoy. You found it irritating, frustrating, angry-making because it seemed unconnected and chaotic. Perhaps, in this situation, all you can do is to lie back, relax and go with the flow. Similarly, for those of us who are trying to cope with the inevitable turbulence of marriage, or long-term partners, you realise that you cannot control your relationship and should not try to. You have to go with the flow.

Public ordering to...
private ordering

What does that mean for us in our lives? What is the meaning of all this turbulence and where are we going? Somebody said to me once that what is really happening is that private ordering in society is taking over from public ordering. This needs translating. He meant that in the past, so much of what we did in life was arranged and ordered for us: where and when we went to school, how long we worked, how much we earned, even the conditions for divorce. More and more, nowadays, it is up to us.

Divorce in England may soon be a private matter. You will give yourself twelve months by law and then, if you wish to separate, for whatever reason, you separate. That is all right. It is private ordering. You will also be able to get £1,000 to send your four-year-old to whatever kind of nursery school you want to. You do not have to, so it is private ordering, not public

ordering. My wife got her degree at 50, not 21, by her choice. It is up to us; it is the new freedom. Isn't that exciting? Except that we have to decide for ourselves what it is all about. Is life just a carrot, or is there something else?

The second curve

We inhabit a confusing and puzzling world and it shows up in all sorts of ways. We are now entering the age of the second curve. The first curve is the Sigmoid curve – the S-shaped curve which tells the story of products, of businesses and of life itself. It has been the form of certainty in our lives for so many generations.

There is a slow start to this curve and a bit of a dip at the beginning, as you invest in others or others invest in yourself or in your products. Then you pick up steam, until you reach success, and the curve peaks. Following this, predictably, the products decay, the business closes down and the wrinkles appear, we get slow-

er and there is no more ski-ing this year. And so it happens, and then it ends.

That was fine, because over eight or nine decades you could spread it all out and see where you were at any moment on this nice curve. There was time to adjust to the changing slopes. Unfortunately, things have speeded up. The scale along the bottom now represents years, not decades. Now we proceed through the Sigmoid curve in so much of life, in so many careers, so many businesses and so many products in five years, perhaps ten years. Nowadays, the average product only lasts eighteen months, and my son tells me that relationships are currently down to six months!

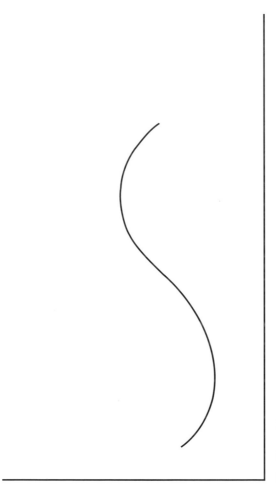

The Sigmoid curve

It is the second curve that gives us hope. If you want to go on growing and developing in your life, or in your business or in your products, you must start a second curve before the first curve fails, which means that growth can continue, but with a difference.

Starting that second curve is a big problem. Whether you are in business or an individual, you need to begin on the second curve before the first curve peaks, so that you can pick up momentum and keep up the head of steam. The problem is that at point A on the first curve all the messages are that you are doing fine, that you need not change a thing, that life is OK. It does require great courage to start that second curve.

The history of change in organisations and, moreover, in life is that you do not start instigating change until you reach point B, when you are frightened. Energy is only released when it is too late. I meet many people at point B who

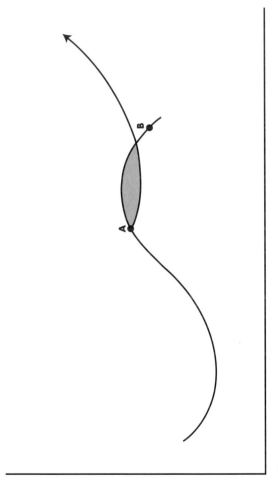

The second curve

say, 'If only I'd realised that I was going to be made redundant when I was fifty-four, I might have left when I was fifty.' The trouble is that life can be understood backwards, but you have to live it forwards, which is always a complication. However, if you can take some time from your first curve at its peak to invest in the second curve, then life can go on being interesting.

Like so many people my age, I like to tell people that I am now on my second marriage – but with the same woman, which does keep it in the family! What we did initially was to have a typical traditional marriage on the first curve. I made the money and she kept the house and family going. This was fine as long as we had the children and they were still at home. When we were at home we had something in common to talk about and care about, mostly the house, the children and the in-laws. Then the children left home and the in-laws died and what did we have left to talk about?

We redesigned the contract, because I noticed that nearly everybody who moved on into their

second marriage, often did this with the person they worked with. So we did it the other way round. We decided to work together which meant that we wouldn't have to marry anyone else! More seriously, we created a second curve in our relationship, I left my job to work on my own, she became my partner and agent. This allowed us to go on growing. It was difficult, but in different ways than before. I have seen other people find their own second curve for their lives and their careers.

Change is constant. The days of the long-lasting first curve are over and we all have to find our second curves, perhaps once every five or ten years. This is not necessarily the case within our relationships or marriages, but it is certainly true of the kinds of things we do with our lives and the things we do with our businesses. To succeed, however, we must be clear in our minds where we want that second curve to lead to, and the third curve, and the fourth curve. As a result the meaning of life becomes a much more crucial question than it ever did when I handed

over the problem to Shell many years ago. Then life was simple; but predetermined. Now it is freer, but very complicated.

two

CLUES
MEAN

TO
NG

The life-line

We have assembled some theories and some clues to help us in our search for meaning. Here is an exercise: without pausing for thought, draw a line to illustrate your life from birth to death. Next, mark the line with a cross to show where you are currently on it.

When things are interesting you draw lots of ups and downs, and when they get very boring you just draw a straight line. One section could be five years, another stretch one year. Time seems funny, rather like Einstein's time, in that it expands and contracts. Having drawn the line, you have to explain to yourself, or to your friends, why you are going up and down on your line. What is the vertical axis for the graph you have drawn?

You can tell a lot about people from the way they draw their line. Some people do straight lines at first, some do circles, most end up with ups and downs when they have thought about

it a little. One man's line was quite straightforward, as he described it to me, every time it went up was when he got divorced, and every time it went down was when he got married. There was clearly a message there! The line tells you what is important to you. We need to be told, because we often do not know what drives us. Money usually turns out not to be significant, which surprises many.

The other curious thing is that most people's lines tend to go upwards towards the end. People must be optimistic by nature or believe that they can make things better. The question is how can we make things better? What is the meaning of this line and what are people's real priorities and values in life?

I cannot answer that for you. In order to find some answers, people have to draw back from life occasionally, to concentrate on the things that really matter. When people are very busy they lose themselves in their busy-ness and are unaware of anything, apart from the little bit of

the world that they are occupying. This is when it is necessary to use the arts of different sorts to help us step back and recover our perspective.

St George's Chapel

For a time in my life I had the strange privilege of living in Windsor Castle. It was an odd kind of village life.The most interesting thing about Windsor Castle is St George's Chapel. Set in the middle of the castle it is an exquisite mini-cathedral. It was my habit to go there as often as I could to listen to the choir singing evensong and to gaze at this extraordinary piece of English perpendicular architecture soaring up above me. It was built by people who knew they would never see the finished article because its completion would take more than their lifetime. I used to wonder about their motivation, why they laboured so hard for a result they would never see. It was a form of meditation for me.

I find, now, that I use the theatre, music, paintings and the arts in the same way, to give me some kind of new insight on that line of mine and what the priorities are, and to remind me that life is never easy. Life is mostly a conflict, not of right and wrong, but of right and right.

Antigone, The Suit

When I started teaching business students at the London Business School, I put two books on their desks on the first morning of term. One was *The Meaning of Company Accounts*, which was a means of survival in their complicated world. The second was *Antigone* by Sophocles. Students used to look at this in amazement, wondering if they were in the right place. I would tell them not to worry as the text was translated into English, not in the original Greek.

My course was not on the great works of classical literature, but we would read *Antigone*

and they would think about it. There would then be a discussion on what the dilemmas are in the play. The brother of the heroine (Antigone), fought their uncle in a war for Thebes and the uncle won. Her brother was killed and dumped outside the city walls. Creon, her uncle, forbade anybody on pain of death to touch the body or do anything about it. That was the law of the land. However, Antigone's law, her law of the gods, said that she must not leave her brother unburied. If he was left to be eaten by the vultures and the crows, great pain and tragedy would fall upon his family and his house. Antigone was thus torn between right and right, between what she was told to do and what she thought she ought to do. It is a Greek tragedy and there is no good answer.

This is the kind of predicament that many of us are faced with. In so much of life it is easier to follow instructions, but people end up saying, 'That wasn't me, I didn't do what I ought to have done.' Antigone may not be an exciting play in terms of words or action. In spite of this,

it is still considered a classic and people will still go and see it. It seems to me that the play addresses one of the most fundamental truths of human life, one of the indefinable things, one of the things that we cannot get hold of.

In the 1995 London International Festival of Theatre there was a stunning play brought over from South Africa. *The Suit* by Can Themba, a leading figure of the 1950s Sophiatown culture, was performed at the Tricycle Theatre in London. In just over an hour the audience was moved beyond the depths of their being. The play is about a man who, because he cannot forgive, kills the thing he loves.

In the interests of keeping control and making the world right, we want to see everybody doing what they should do. If they do it wrong we want to correct them and tell them they are wrong. The man in *The Suit* was doing just that. He was disciplining this person and in the end he killed the one he loved. It is so hard to forgive.

Lure of the 'eight'

We can, however, escape from most conflicts of right and right these days, if we are one of the lucky ones with the all-consuming jobs that go to one half of the population. If we have one of those jobs we are probably in a 'Hot Group', a team with a purpose, an all-embracing purpose which excludes doubt and promises a curious sort of certainty.

I am from Dublin and am, therefore, allowed to tease the English. I used to say that an English team was a contradiction and a paradox, a paradox best illustrated by a rowing eight on the river. There are eight people going backwards as fast as they can without speaking to each other. Steering is in the hands of the one person who cannot row, because you put a chap in charge who cannot do the job – that is called the class system. I thought the analogy was quite witty!

But one day I was confronted by an Olympic

oarsman in the audience. He came up to me after a lecture and said, 'Professor, you've got it wrong. How do you think we can go backwards so fast without talking to each other, unless we know each other terribly well, unless we have total confidence in each other's ability to do the job we are supposed to do, including that little chap who can't row, who is steering, unless we are all absolutely dedicated to getting to the end of the course before anybody else does, and to winning the race.'

He told me it was the perfect recipe for a team. I had to agree. I preach that doctrine now. If you know each other very well and trust each other completely then you do not have to talk while you are doing the job. Everybody can get on with the work in hand. This gives you total commitment to the common goal. It is what is called a Hot Group and it's wonderful if you are in it.

The only trouble is, what happens at the end, what happens if you aren't able to go to anoth-

er Hot Group? The danger is that you get so consumed by the ambition of this group that you are actually not much use for anybody else. At the time, it can seem as if that is all there is to life.

If you walk around the United States these days, in, for example Silicon Valley, or Microsoft in Seattle, you can see people consumed by their jobs. These are people who sleep in their offices all week long.They meet their wives (who soon cease to be their wives) only every third Sunday. There are people who have commuter marriages. They meet in an airport lounge once a fortnight because their jobs are so consuming. They say it is wonderful!

I had a job like that once. I got home occasionally; I saw the kids when they were tucked up in bed and I left before they got up in the morning. I thought the kids were wonderful, no trouble at all. My wife said to me one day, 'Is your job going well?' and I replied, 'Yes, it's really exciting.' And she said, 'I'm glad. I just

thought you ought to know that you have become the most boring man I know.' In the end the job goes and, of course, you are left as the most boring person people know.

The gospel of Thomas

Think now of the gospel of Thomas, one of the Gnostic gospels, the non-official gospels of the early Christian Church. It has this quotation:

'If you bring forth what is within you, what you bring forth will save you. If you do not bring forth what is within you, then what you do not bring forth will destroy you.'

We realise that there is danger and an allure in the all-consuming occupation, and it gives you a meaning for a time, but beware, because it may not be the whole of you. It is a cancer. It is your duty to yourself to do what you have to do.

By the time you die you will only have discov-

ered 25 per cent of your natural talents. This is an unprovable assertion, yet I believe it to be true. When I talked about this on the radio I received some angry letters. I was told that not everybody is as privileged as Charles Handy. They cannot all do what they want to do. Some people just have to do what they don't want to, in order to bring home the bacon. I agree. But consider The Three Steps.

The three steps

There are three steps to meaning, a sort of step ladder of life. The first is *survival*. One has to survive. If that is crucial, then it gives you enough meaning to make sense of life for a time. There are indeed politicians who would like to keep most of us at a level of basic survival, because that will keep us all busy. There would be no nonsense about leisure, time to think, or anything like that. That was Plato's idea of a just society, in which everyone knew their place. Fine, if you are one of the top people, a

philosopher king, but if you are one of the serfs, then tough luck. If you were busy earning your living and surviving then you would be, in a sense, content, but hardly happy. There are political creeds that want that for our society, but I do not.

I believe that there needs to be the chance to get on to the second step of this ladder, the one of *identity*, proving yourself in the world, getting noticed in some way, earning your label in life. Work is the place from which many people get an identity. Others get it from relationships. If you want an identity, you get it by giving, because you need to matter to someone else, both at home and at work if you are to matter to yourself.

When you have achieved the step to identity, there is the third and ultimate step. It is *to contribute*, to make a difference to the world in some way and to make a difference to other people. If you stop at the second level you are being purely selfish and, will find, ultimately,

that is not as satisfying as making a contribution. But to contribute you have to first find yourself.

Find yourself... a special artist

The Greeks believed that our main purpose in life was to find ourselves. It is not easy. The Director of The Boston Fine Arts Museum once said, 'We used to think that it was a special sort of person who became an artist or an actor or whatever. Now I think that's wrong. I think that every person is a special artist in some way.'

I also like the Japanese idea that life is a game. I do not mean a trivial child's game, but a serious game, a challenge. It is our job to excel in this exercise, this game of life with whatever particular form of artistic skill that we have. I believe that we are, each of us, in some way a special artist, but to find what kind of artist we might be, we need to travel on a horizontal fast-track in search of our special intelligences.

three

THE
AIDS
MEAN

O
NG

Horizontal fast-tracks

The Japanese told me once, that they used 'slow-burn development' in their organisations. Everybody took fifteen years to become a manager. I asked whether there was a fast-track for the talented people and whether this meant they moved onto the Board more quickly. The Japanese reported that they did have a fast-track, but that it was horizontal: 'The really good people, we shush them around faster, so they get more experiences quickly. They can take more in.'

Ten-fold intelligence

In life, since we do not know which talents we really have got, we try to zoom around to find out what kind of artist we are. It is my belief that we are all intelligent. There is a new theory of multiple intelligences originating with Howard Gardner of Harvard University. There are at least ten intelligences and nobody has all of

them. Everybody, I believe, has some of them,
even if it is only one or even if they do not
combine.

Let me go through them all, to give you exam-
ples, bearing in mind that they do not neces-
sarily correlate. You can have one without the
others. There is factual intelligence, the master-
mind intelligence, the brainbox who knows all
the stuff, but maybe cannot use it. Then there is
logical intelligence, people who can reason. If
you combine those two intelligences, as some
people do, then you do especially well in
exams. If you add the third intelligence, which
is numeracy or numerical intelligence, then you
do even better in exams.

Some people have only numerical intelligence,
but cannot actually talk. Or, if you can talk intel-
ligently, you may not be able to count. Then
there is spatial intelligence, that artists or entre-
preneurs have. They see patterns where other
people do not. Computer programmers may be

stupid and no good at getting into university, but brilliant at seeing patterns that nobody else can. This is why Richard Branson does so well. He has got that particular pattern of intelligence. There is also musical intelligence. Most pop groups do not get to university, but they earn a fabulous amount of foreign currency for the country. Then there is linguistic intelligence. Some people are lucky and talk seven languages. Though, as a friend of mine said, he talks nonsense in all of them because he hasn't got any of the other intelligences.

There is also the practical intelligence that we call common sense, and a physical intelligence that we call athleticism. There is psychic intelligence that some people have, particularly people that are often handicapped in other ways. They have an ability to know what you are thinking – empathy.

Lastly, there is interpersonal intelligence, the ability to get things done with and through other people. This often does not correlate with any

of the others. When people used to apply to the London Business School with top grades in mathematics, reasoning and facts, the evidence was, with some candidates, that they had no interpersonal intelligence. Interview panels would conclude that they would be a lousy manager. We were concerned to see whether they had ever made anything happen in life, besides counting it and writing it down.

Some people are lucky and have three or four of these intelligences. Some people have five. I believe that everybody has one. I cannot prove it, yet everybody can be an artist in this great game of life and it is up to us to make sure that they do. It is up to us to give them every opportunity to do so. We must give them a chance to understand that the great indefinables of life can only be found by walking in one way or another into the arts. But we all need help to be our own special artist.

Work should be theatre

I would like to see business and the workplace becoming more like theatre. I am intrigued by the world of Disney. Disneyland in Florida (not in Europe) is meant to be the best managed service organisation in the world. People do not have jobs, they have parts. They do not have job descriptions, they have scripts. They are either on-stage when they are working, or off-stage. They do not have managers, they have directors. Disneyland has deliberately used the language of the theatre. The message is that this is a game in which we can all excel.

Returning to the subject of the London International Festival of Theatre, I have to say that I am astounded at its efficiency and organisation. This is an event that involves companies from places all over the world; there are hordes of volunteers staffing the office. All the signs are that everything is running perfectly smoothly. I look in vain for the shining limousines, I look for the smart job titles and the badges of rank: they

don't exist; this is invisible management at its best. I have never actually heard the word management in the LIFT offices. It is fashionable under-management, perfectly understood. I wish I knew how they achieved this. These people should be great professors in our business schools.

Beyond profit

The theatre and the arts have things to teach all of us; just as the voluntary world has things to teach us about how we run business. Profit is not what it is about. Nobody ever jumped out of bed in the morning thinking, 'Ha! I'm going to make the shareholders seriously rich.' For people who make lots of money out of private business, money is the score card, but financial gain is not really why they are in business. You don't play cricket to get a batting average, you play cricket for the love of the game.

Our businesses will only be ultimately successful

if people are in them for the love of the game, as they are in the arts and as they are in the voluntary world. It is in these areas that management is a service, not a privilege.

We need a new dream

We have much to learn if we want to give meaning to our organisations. We need a new dream for our society. Not a dream where the economy grows (though that would do no harm), but one where everybody is enabled to be an artist in this great game of life. We must all strive after this.

Let me describe three old paintings which will give you some idea of how art can make you think. I would have liked to use illustrations from theatre, but photographs of the theatre do not really work so well.

Firstly, there is Goya's 'Rib, Loin and Head of Mutton': a carcass on a butcher's slab. This is a scene painted in the middle of one of Spain's many wars. The image is saying to me that all I am is simply a hunk of meat and that I might as well have a beer, go home and forget about life, the meaning of life. War reduces you to the lowest rung of life's ladder of meaning. Is that what we really want?

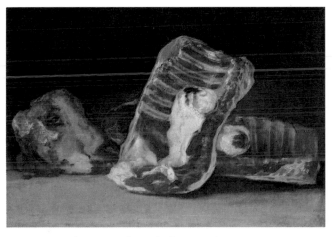

'Rib, Loin and Head of Mutton' by Goya

From the same exhibition of Spanish still life, which was shown during the spring of 1995 at the National Gallery, there is a painting called 'Vanitas' by Antonio de Pereda. Here we see somebody looking at all the riches of the world, but also at a skull. So what do all the riches matter? How about a tombstone? The inscription could be: Here lies Charles Handy, he spent two million pounds, lucky chap! Is that what identity is all about, that second step? Surely not.

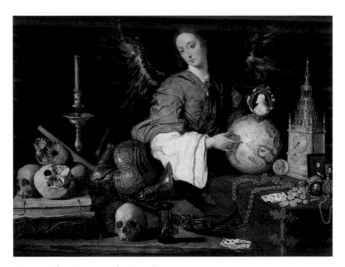

'Vanitas' by Antonio de Pereda

The last picture is from Florence. 'Trinità' was painted in Santa Maria Novella by Masaccio, the year before he died aged twenty-eight. Above is the crucifixion, below is a gravestone of two Tuscan people, man and wife. A skeleton utters an old Tuscan motto, 'What you are I was. What I am, you will be.' The people we see below the cross are Mary, the Mother of Jesus, and John, his favourite disciple. However, neither Mary and John, nor indeed God the Father, above, are looking with horror at Jesus dying on the cross. They are not exclaiming in agony. It seems to me they are saying, 'Look at this person and think — what a life this Jesus had. What a life that was!'

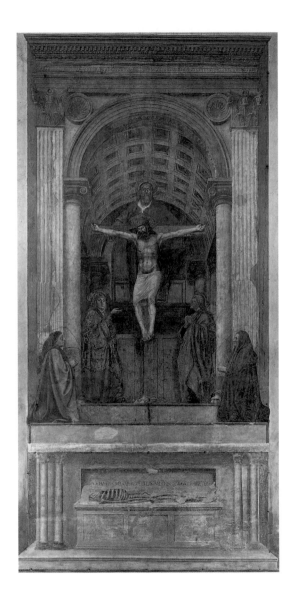

As I see it, our challenge is to ignore the skeleton. We must end up as more than bones. We should want people to say, 'What a life that was; he, or she, played the game of life as a great artist.'

Opposite: 'Trinità' by Masaccio

My final reference to the LIFT is about a French circus, Cirque Plume. There were no animals, just ordinary people doing fabulous things. It was, ultimately, pointless, but these were great artists showing great skill in the game of life, ordinary people making magic, not for much money but just for the thrill of it, and the challenge of excellence. And we went away exhilarated.

As a businessman said to me afterwards, 'Why do we have to bribe our people with so much money to work as well as this. Are we missing something?' I would like more people in this society to have a chance to be great artists in the game of life, both in their businesses and in their homes. It is our job to help them.

charles handy

QUEST
& AN

IONS
WERS

Questions and Answers

You have not actually used the word 'spirituality', but it is clearly a word that resonates through the whole tone of what you say. Do you see a growing spiritual revolution, that there will be more spirit in business?

CH I hope so. I think there is a yearning in life for this thing that I call meaning. I avoid the word spiritual, because it does have the wrong connotations for some people. There is a wonderful book on management by James Autry, called *Love and Profit*. He is an American businessman, but he is also a poet.

'Listen,
in every office
you hear the threads of love and joy
and fear and guilt.
The cries for celebration
and the reassurance.
And somehow you know that connecting those
threads is what you are supposed to do.

And the business takes care of itself!'

That seems like wishful thinking, but I really do believe that if we had more joy, celebration and love and had a cause beyond profit, then life would be much more exciting.

I work in the arts and feel that I am part of a 'Hot Group', with a lot of love and support and there is tremendous enthusiasm for the work we do. However, like many colleagues in the arts world, we are facing increasing 'business-ification' of that very thing that you are saying is so precious. We are facing slimmed-down organisations and coercion to adopt things from the business world. What about that pressure?

CH It is ironic. At the moment when business is starting to head in a different direction, the rest of society is emulating the business of yesterday. Business is now much more concerned about effectiveness than about efficiency. Of course efficiency matters, but business is now discover-

ing that the quality of what you give is what really matters and will justify the increased costs. Proper effectiveness will cover efficiency.

But the non-business sectors, such as hospitals and education, are so hell bent on efficiency that some effectiveness is going out the window. I think that we should be learning from business today and not business yesterday. If the effectiveness of what happens ensures the quality of what you produce, then people will pay.

What about the portfolio person who needs so much more interaction than that sort of life can give, someone who needs to be part of life?

CH I am not advocating the portfolio life. I am saying that it is inevitable. It is going with the flow to some extent. Organisations are slimming down. If we do not actually take our destiny in our own hands, we will be sitting waiting for nothing, like the people in the theatre

piece, *Murx*.

Organisations were dreadful places in some ways, but they were places where companionship could be found. We will miss a lot of what organisations used to offer, the familiar faces we liked and people we hated, the canteen and the gossip. Now we interact only with clients or our competitors. I think we have to find an alternative community of some sort, where we can refresh ourselves and relax. Because loneliness is to me one of the great sadnesses of the portfolio life.

You have said that the more you know about life, the more you realise that you are a 'pimple'. You also commented on how hard it is for us as individuals to make a difference. Despite this, you have managed to fill me with enormous optimism and I sense your optimism about the contribution that we can make. I am wondering how you pull these two things together, that on the one hand we are 'pimples' and on the other hand we can make a significant contribution.

the search for meaning

CH The point is that now we are bombarded with so much information, from television screens for example. We can see what is taking place all over the world. This tends to make us feel insignificant. I was trying to say that we are not insignificant, in fact. We have to act on our own stage in our own place. Although we cannot change the whole world, we can change our little bit of it.

We need not, must not, wait for the government to do it. Governments follow, they don't lead. When I was young, I used to think that people in government had the right answers, that they knew everything. Now I am so old that some of my students are up there and I *know* they don't know everything.

You suggested that we should be encouraged to find whatever is our particular artistic ability. But later on you mentioned that 14 per cent of people are unemployed, or in some way alternatively employed. If people have no income from traditional work, whether

they are unemployed or simply at home, how do you reconcile that lack of income with the ability to give productively of their artistic side?

CH This is difficult. I want huge investment to make sure that this does not happen in future generations. I want a national curriculum that is about process, rather than content. I do feel strongly that it is the first duty of a school to find out which forms of intelligence you have, so that you can always earn your way in life and make a contribution. It is a fact that nine out of ten people aged sixty in this society left school at 15 and have not had much education ever since. We have deprived a lot of people of a chance to make a contribution or even to survive.

Our first duty, however, is to make sure that people survive, that first step on the ladder of meaning. I am in favour of a citizen's income of some sort, though the practicalities of this are difficult to devise. It should be your right as a citizen to

get enough to live on – without this being demeaning. Then, as you earn more, you could pay it back.

If survival is taken care of, then you can go on to find your identity. But if nobody in your house is earning, then you become like the people in *Murx*. You just sit around and wait, because you don't think you can do anything. It is difficult to break that. But we must try. We can all, in some small way, aspire to be a special artist in the theatre of life.

In Memory of Barney Simon

the search *for* meaning

In 1995, the Festival Directors of LIFT invited Barney Simon, Artistic Director and Co-Founder of the Market Theatre, Johannesburg, to give a lecture as part of the eighth London International Festival of Theatre.

Barney Simon's pioneering work at the Market Theatre in commissioning and presenting Black artists during the years of apartheid is renowned worldwide. Legendary productions included *Woza Albert!*, in which a bewildered Christ returns to Earth as a Black South African. Barney Simon's unique vision of theatre's relationship to society ensured his place as the spiritual leader of theatre in the new South Africa. Programmed to sit alongside Charles Handy's exploration of *The Search for Meaning*, Simon's lecture was to give the artist's view of historic social change. Entitled *Miracles in Hell,* the lecture was scheduled to coincide with the opening night of his latest, and possibly finest, Market Theatre production, *The Suit.*

A severe heart condition prevented Barney from travelling to London from South Africa to give the lecture and he died from complications following major heart surgery.

The seeds for Barney's LIFT Lecture however were sown during an acceptance speech given from the stage of the Market Theatre early in 1995 on receiving an award of $50,000 from the Jujamcyn Foundation for the Market Theatre's role in changing South African society. Spoken from Freud's study on the theatre set of *Hysteria*, Barney Simon intended to use this speech as the starting point for a lecture, mapping his own experience at the Market Theatre, on the ways in which 'art is constantly at work educating the spirit of the age.'

Whilst the lecture will never now be heard, the spirit and confidence imbued by Barney Simon in a generation of South African actors and theatre makers to tell their own stories, will continue to bear fruit for years to come.

'We thank you and Jujamcyn for the honour of recognition that you have given to us for our role, you say, in proving that art can change society. When I was fourteen years old I had girl friend who was always telling me never to contradict a compliment, because I always did. I hope that I am not offending her now, wherever she is. But may I submit, rather, that we at the Market Theatre are part of a changing society and that we have attempted, consistently, to nurture it. Of this I am proud and I hope that we can keep your award.

Again, perhaps inappropriately, because I am standing in Freud's study, may I quote Jung. He wrote that artists often serve their cultures and epochs in ways that are veiled and not immediately understood. That art is constantly at work educating the spirit of the age, conjuring up the forms in which the age is most lacking and compensating for the one-sidedness of the present. I think that is part of what we are trying to do too.

I believe that we live in a place of miracles. I

have not seen a burning bush, except in a veld-fire or two. I have never followed a travelling star or even fantasised a flying saucer. But that is not a complaint. The miracles that interest me are not wonderful or delightful or much to do with the divine. The ones that I like best are those that give evidence of the grace that is in all things. They are the hardest to come by in a world as tormented as ours. There might be miracles in heaven, but I suspect that they are not nearly as rewarding as miracles in hell. Every adult South African was born into an insane world. Insane because it denied and confused mankind's greatest gift, the equality of our humanity. We were forced to behave as if cultural differences between human beings were stigmas, separations, that curiosity and passion could be crimes; and we were denied the dignity of even comprehending the lives being lived beside us.

Johannesburg was not founded beside a river or a bay, as sensible and decent cities should. It was built on a barren stretch of land because

gold was found beneath it. And because of that gold, the greediest and most dangerous men in the world gathered. And here is a miracle: despite our beginnings, our landscape, our grace is our people. Multiple, vivid, absurd, treacherous, generous, adventurous, divinely pragmatic and always capable of our sound of survival: laughter. We who began the Market Theatre did it out of love for this landscape and committed ourselves to it.

Freedom through legislation has come suddenly and swiftly, and that is cause for great celebration. But freedom of the heart and mind is lagging far behind. It is that freedom that has always been our concern, and remains it. We know that for a time we will continue to live in contradiction and confusion. We have watched like celebrations wither, rooted as they were in devastation.

Our new South Africa is very, very young. We struggle every day to realise the difference between what was and what is. To render jus-

tice finally imaginable, if not yet real, in a world so long abused.

You honour us for what we have been. I hope that it is also for what we are. We undertook a task in the terrible year of 1976, that many called, according to their prejudices, absurd, criminal or superhuman – which is my prefer ence. It is not a vanity. Camus said that tasks are called superhuman when men take a long time to complete them. We are very far from completion. Our journey is as various and difficult and extraordinary as any that strive for dignity and clarity in our time.'

Barney Simon
The Market Theatre, Johannesburg
February 1995

Acknowledgements

Permission to reproduce the following pictures is gratefully acknowledged to the respective copyright holders:

Page 67 'Rib, Loin and Head of Mutton' by Goya. Kunsthistorisches Museum, Vienna

Page 68 'Vanitas' by Antonio de Pereda. Louvre. Agence Photographique de la Réunion des Musées Nationaux, Paris

Page 70 'Trinità' by Masaccio. S. Maria Novella. SCALA Istituto Fotografico Editoriale S.p.A., Florence

Index

The LIFT Business Arts Forum

Are you interested in professional development through the arts?

Charles Handy and LIFT, together with the Financial Times, spearheaded 'a pioneering experiment in business education' during the eighth London International Festival of Theatre. Artists and participants from the business community attended LIFT events to learn about different cultural perspectives in a rapidly changing world.

If you would like to receive further details about the LIFT Business Arts Forum, please write to:
Julia Rowntree
Forum Director
LIFT
19–20 Great Sutton Street
London
EC1V 0DN.

The LIFT free mailing list

Would you like more contact with the theatre?

To receive information about forthcoming contemporary performance events, including the next LIFT Festival, join the LIFT free mailing list.

Every six weeks or so, you can also receive details of a range of arts events with special discounts.

Please write with your name and address to:
LIFT
FREEPOST WC5328
London EC1B 1LF.